## DATE DUE

| | | | |
|---|---|---|---|
| | | | |
| | | | |
| | | | |
| | | | |
| | | | |
| | | | |
| | | | |
| | | | |
| | | | |
| | | | |
| | | | |
| | | | |
| | | | |
| | | | |
| | | | |
| | | | |
| | | | |
| | | | |
| | | | PRINTED IN U.S.A. |

LIGHT IS THE THEME

# LIGHT IS THE THEME:
# LOUIS I. KAHN AND THE
# KIMBELL ART MUSEUM

Comments on Architecture by Louis Kahn

Compiled by Nell E. Johnson

Kimbell Art Foundation, Fort Worth, Texas    1975

Kimbell Art Museum Publication Two

First Edition, 1975
Second Printing, 1978, with minor revisions and
updated bibliography

© 1975, 1978 by Kimbell Art Foundation.
All rights reserved

International Standard Book Number: 0-912804-03-3
Library of Congress Catalog Card Number: 78-61163

# INTRODUCTION

Concrete workers, carpenters, trustees, engineers, draftsmen, foremen, curators and contractors—all these, and many more, were needed to build the Kimbell Art Museum. In the making of it we all had one of the grand privileges and opportunities of our lives, for it was not simply making, it was creating. The difference was there because the architect, Louis Kahn, was a great artist. In the beginning, the chasm between his protean vision and prosaic practicality, between idea and embodiment, sometimes seemed unbridgeable. But in the end everyone's comprehension of art's power to enlarge the dimensions of life was increased by helping to realize Lou Kahn's dream.

This book is intended to be more than the visual record of a building, more than a memorial to a beloved man. It is meant as an offering of thanks for his leading us, through his character and his art, to a fuller appreciation of why life is worth living.

All the pictures are of what Lou designed for us. The text consists solely of what he said. Identification of sources for both are given in an index and credit lines at the back of the book. One will also find there a page of basic facts about the building, as well as a listing of those people who contributed significantly to its success.

Richard F. Brown
Director

LOUIS ISIDORE KAHN
February 20, 1901 — March 17, 1974

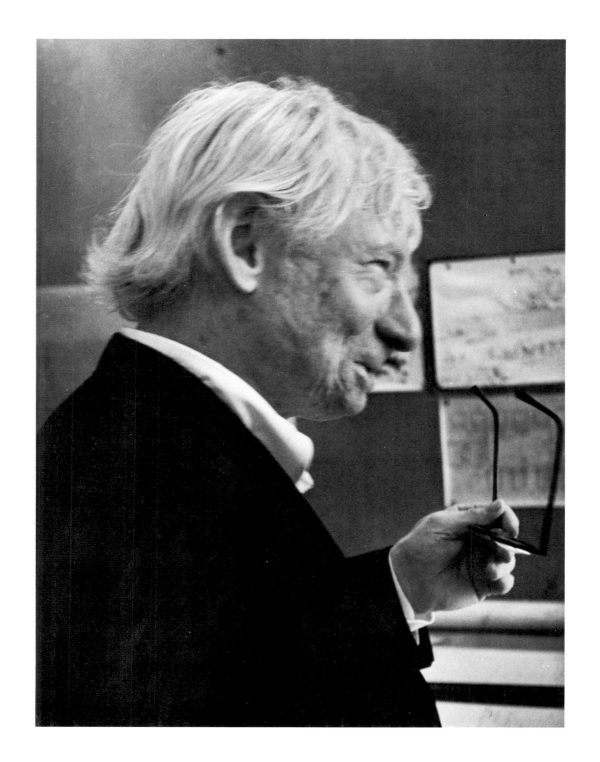

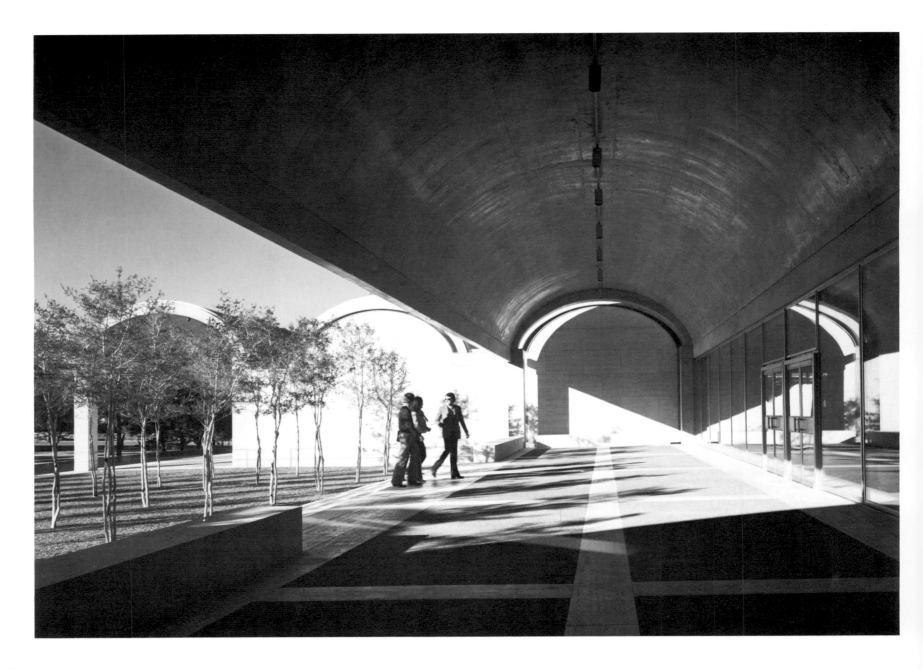

Silence to Light
Light to Silence
The threshold of their crossing
   is the Singularity
   is Inspiration
(Where the desire to express meets the possible)
   is the Sanctuary of Art
   is the Treasury of the Shadows
(Material casts shadows shadows belong to light)

A great American poet once asked the architect, 'What slice of the sun does your building have? What light enters your room?'—as if to say the sun never knew how great it is until it struck the side of a building.

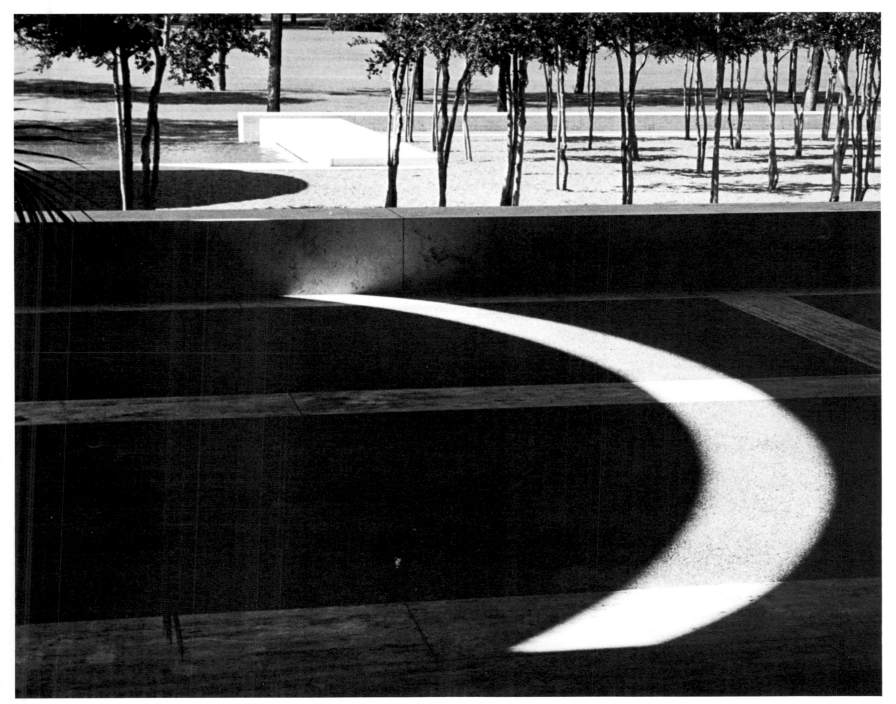

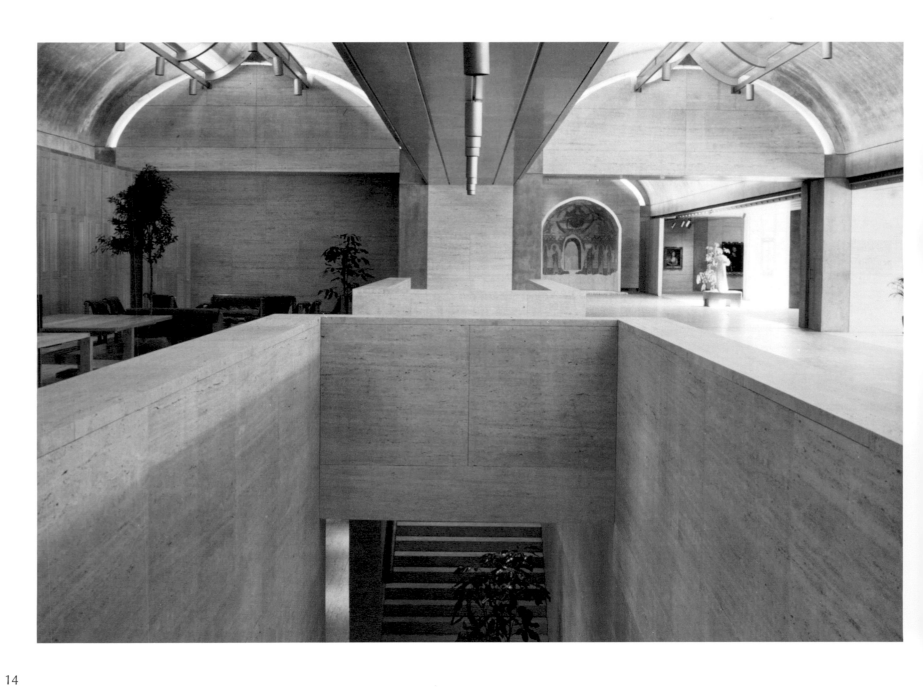

No space, architecturally, is a space unless it has natural light . . . . I am designing an art museum in Texas. Here I felt that the light in the rooms structured in concrete will have the luminosity of silver. I know that rooms for the paintings and objects that fade should only most modestly be given natural light. The scheme of enclosure of the museum is a succession of cycloid vaults each of a single span [100] feet long and [23] feet wide, each forming the rooms with a narrow slit to the sky, with a mirrored shape to spread natural light on the side of the vault. This light will give a glow of silver to the room without touching the objects directly, yet give the comforting feeling of knowing the time of day.

We knew that the museum would always be full of surprises. The blues would be one thing one day; the blues would be another thing another day, depending on the character of the light. Nothing static, nothing static as an electric bulb, which can only give you one iota of the character of light. So the museum has as many moods as there are moments in time, and never as long as the museum remains as a building will there be a single day like the other.

So this is a kind of invention that comes out of the desire to have natural light. Because it is the light the painter used to paint his painting. And artificial light is a static light . . . where natural light is a light of mood. And sometimes the room gets dark—why not?—and sometimes you must get close to look at it, and come another day, you see, to see it in another mood—a different time . . . to see the mood natural light gives, or the seasons of the year, which have other moods.

And the painting must reveal itself in different aspects if the moods of light are included in its viewing, in its seeing. This is another example of what one sets in his mind as being a nature of something. I think that's the nature, really, of a place where you see paintings. And research would never have given it to me because all I could find were ways of doing it completely contrary to the ways I think a museum might be. So it must be derived out of your own sense of its nature, of its service, of the nature of . . . the rooms of a museum.

And the cloud that passes over gives the room a feeling of association with the person that is in it, knowing that there is life outside of the room, and it reflects the life-giving that a painting does because I think a work of art is a giver of life. So light, this great maker of presences, can never be . . . brought forth by the single moment in light which the electric bulb has. And natural light has all the moods of the time of the day, the seasons of the year, [which] year for year and day for day are different from the day preceding.

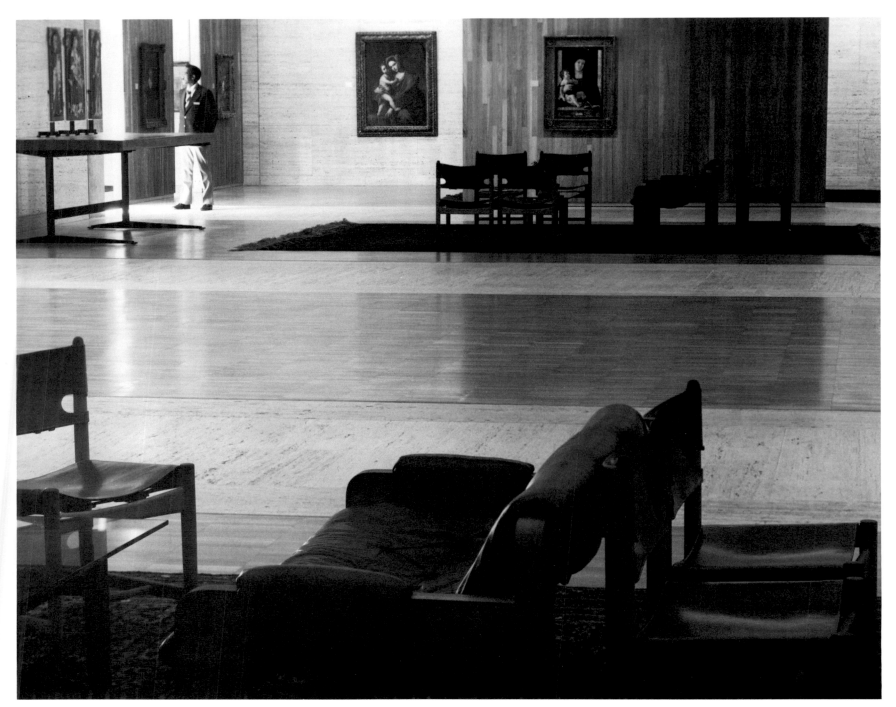

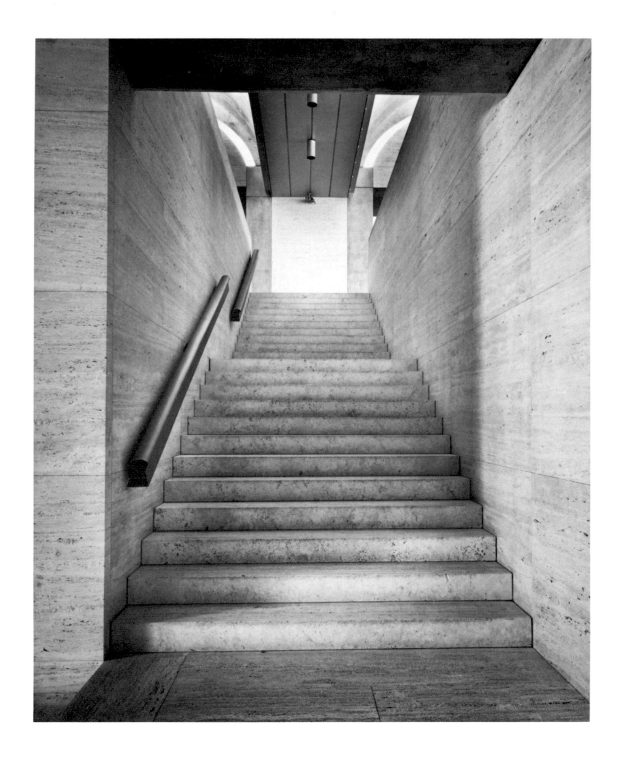

Structure is the giver of light.

A stair isn't something you get out of a catalogue but a very important event in a building.

Added to the skylight from the slit over the exhibit rooms, I cut across the vaults, at a right angle, a counterpoint of courts, open to the sky, of calculated dimensions and character, marking them Green Court, Yellow Court, Blue Court, named for the kind of light that I anticipate their proportions, their foliation, or their sky reflections on surfaces, or on water will give.

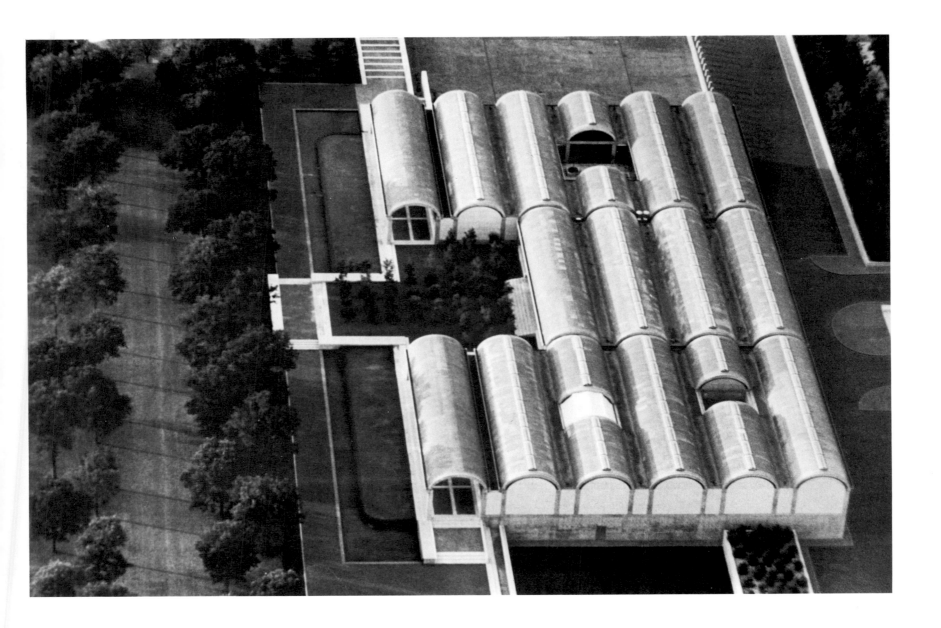

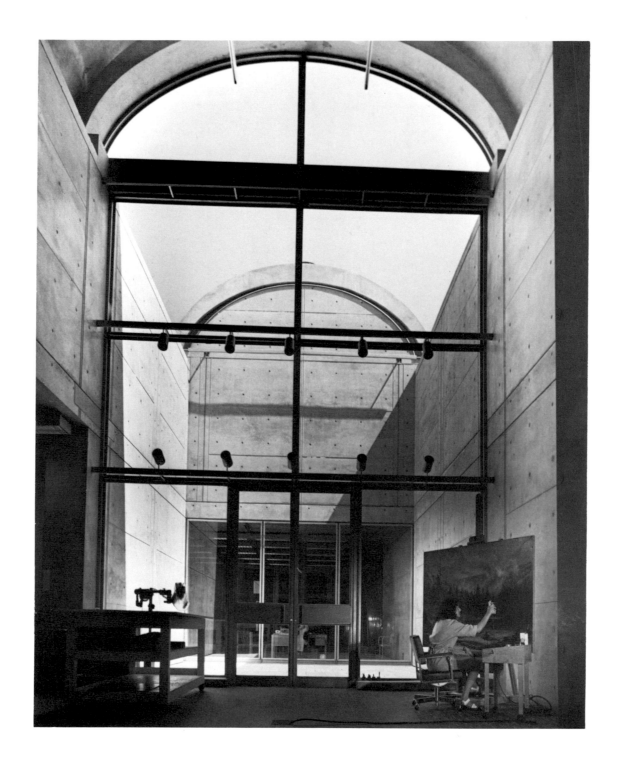

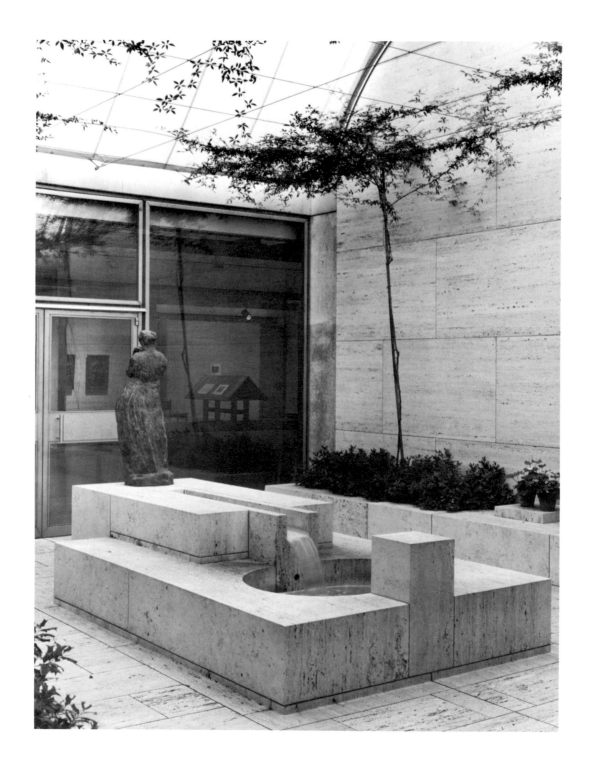

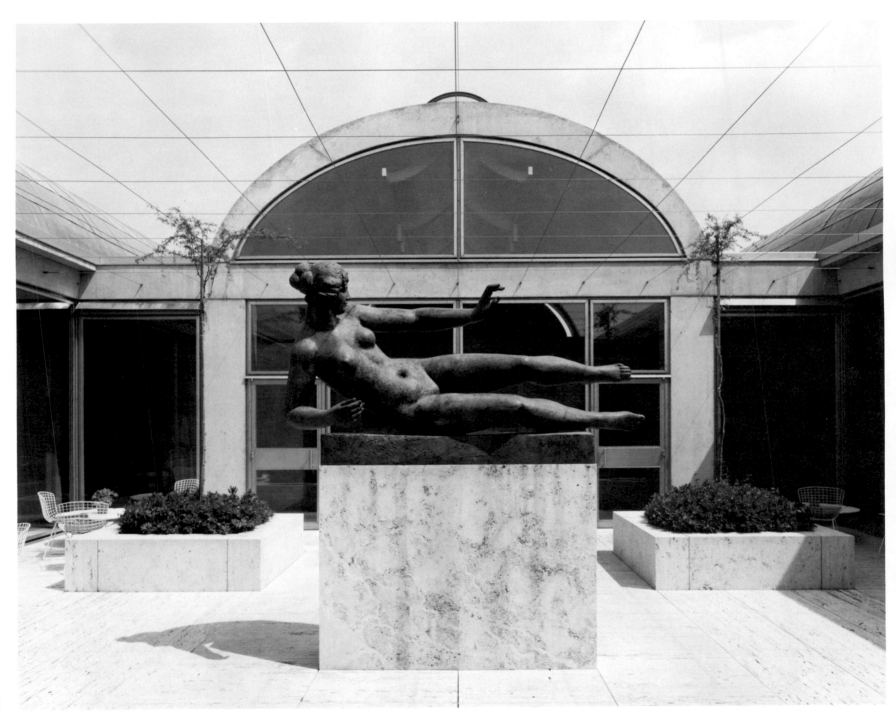

Of course there are some spaces which should be flexible, but there are also some which should be completely inflexible. They should be just sheer inspiration . . . just the place to *be*, the place which does not change, except for the people who go in and out.

Because of the open porches, how the building is made is completely clear before you go into it. It is the same realization behind Renaissance buildings, which gave the arcade to the street, though the buildings themselves did not need the arcade for their own purposes. So the porch sits there, made as the interior is made, without any obligation of paintings on its walls, a realization of what is architecture. When you look at the building and porch, it is as an offering. You know it wasn't programmed; it is something that emerged.

You know what's so wonderful about those porches? They're so unnecessary.

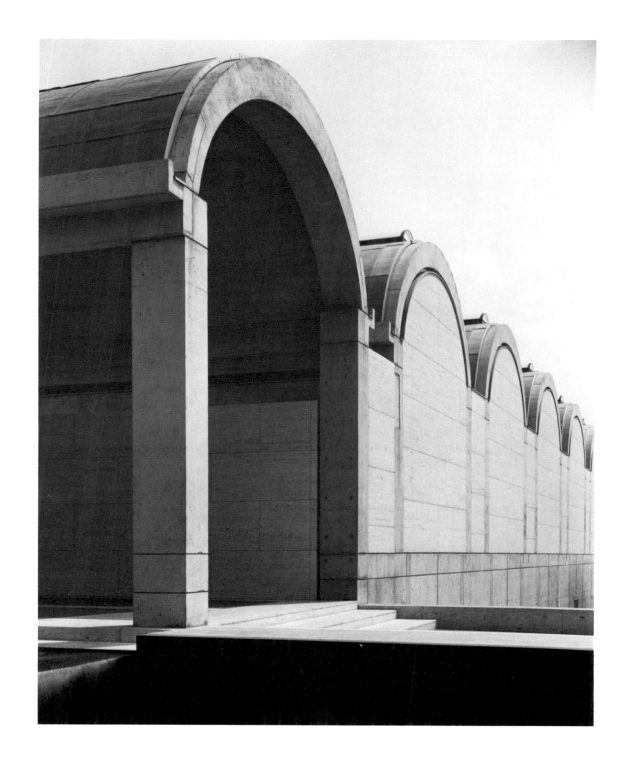

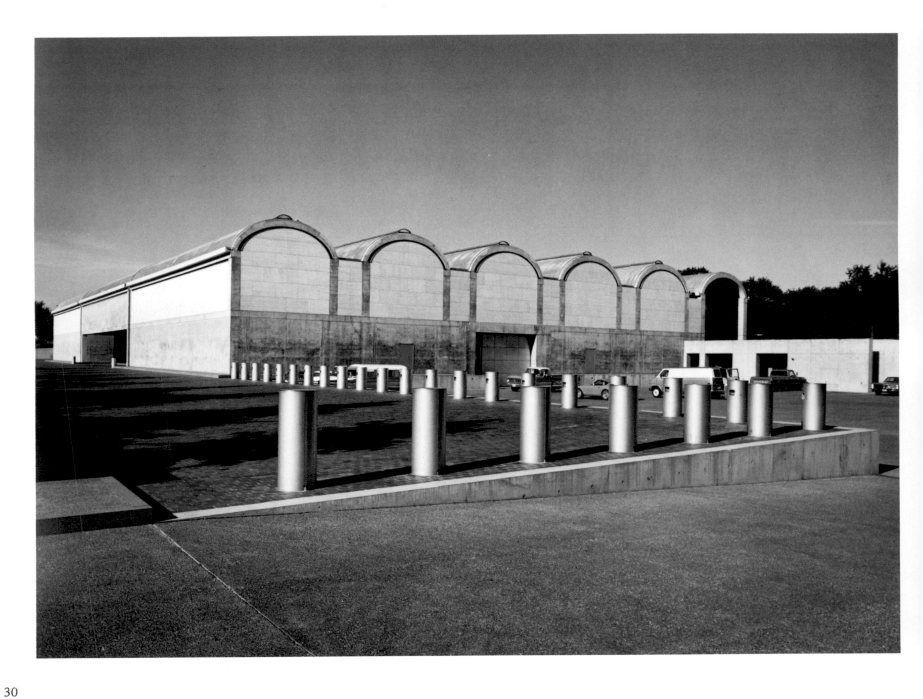

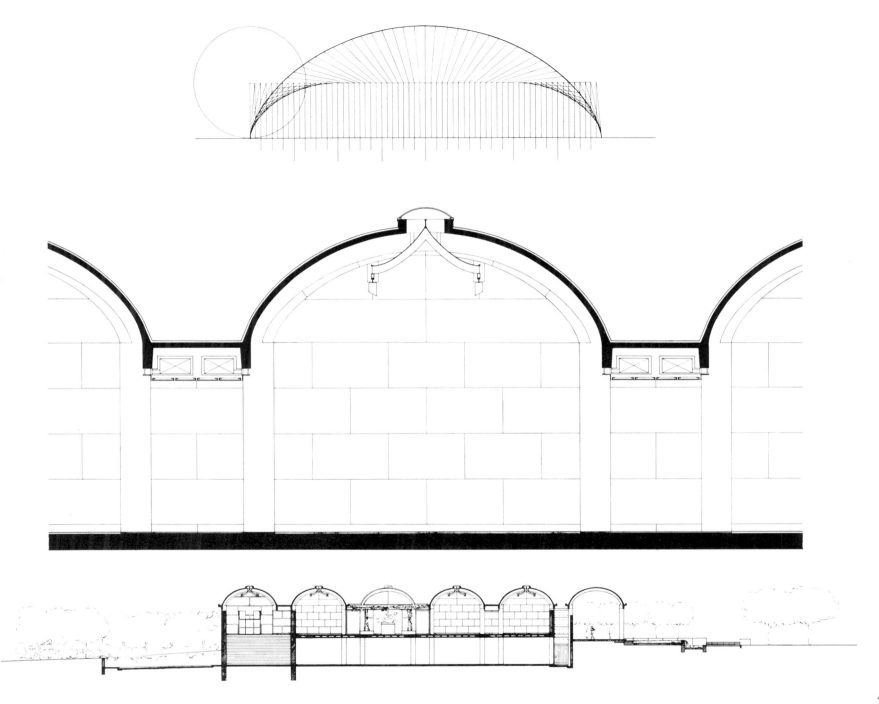

My mind is full of Roman greatness and the vault so etched itself in my mind that, though I cannot employ it, it's there always ready. And the vault seems to be the best. And I realize that the light must come from a high point where the light is best in its zenith. The vault, rising not high, not in an august manner, but somehow appropriate to the size of the individual. And its feeling of being home and safe came to mind.

By the nature of the vault-like structure, you have the play of lofty rooms with a space between each vault which has a ceiling at the level of the spring of the vault. The lower space does not have natural light, but gets it from the larger chamber. In the loftier rooms, how the room is made is manifest; the dimension of its light from above is manifest without partitions because the vaults defy division. Even when partitioned, the room remains a room. You might say that the nature of a room is that it always has the character of completeness.

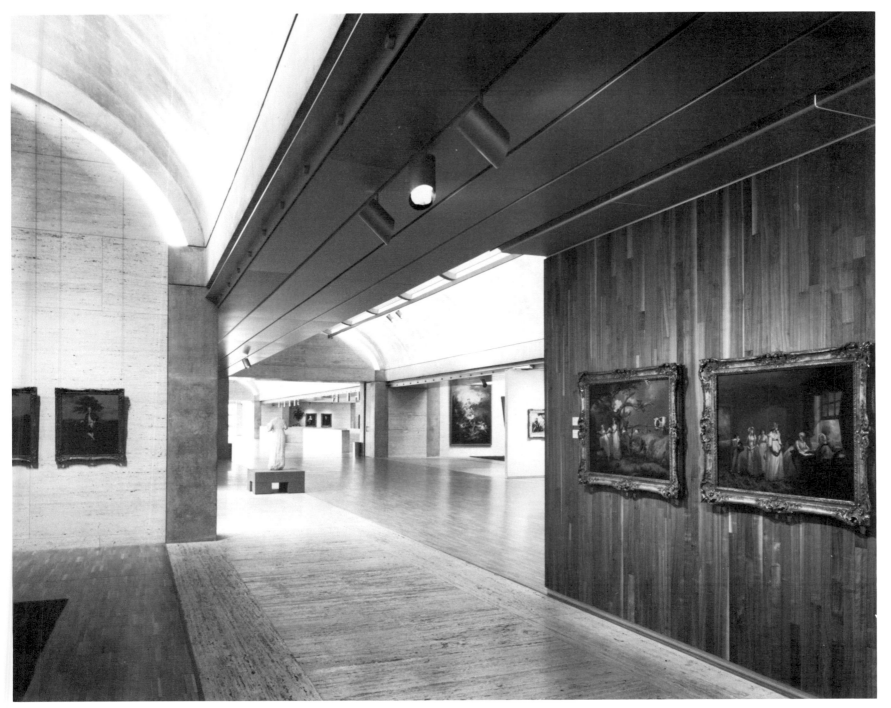

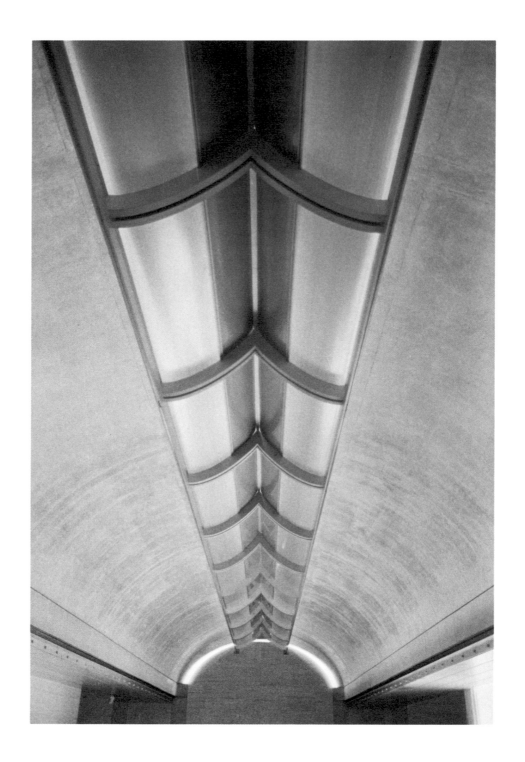

This "natural lighting fixture" . . . is rather a new way of calling something; it is rather a new word entirely. It is actually a modifier of the light, sufficiently so that the injurious effects of the light are controlled to whatever degree of control is now possible. And when I look at it, I really feel it is a tremendous thing.

When a man says that he believes that natural light is something we are born out of, he cannot accept a school which has no natural light. He cannot even accept a movie house, you might say, which must be in darkness, without sensing that there must be a crack somewhere in the construction which allows enough natural light to come in to tell how dark it is. Now he may not demand it actually, but he demands it in his mind to be that important.

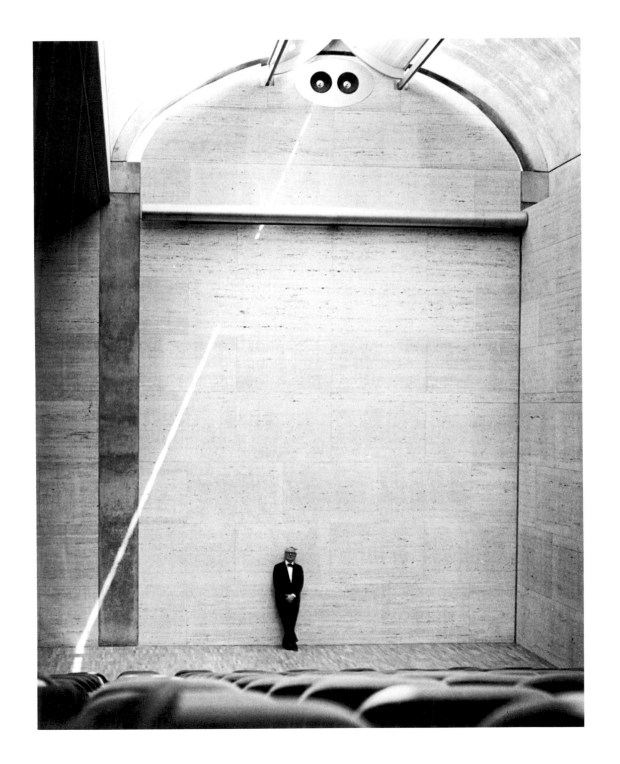

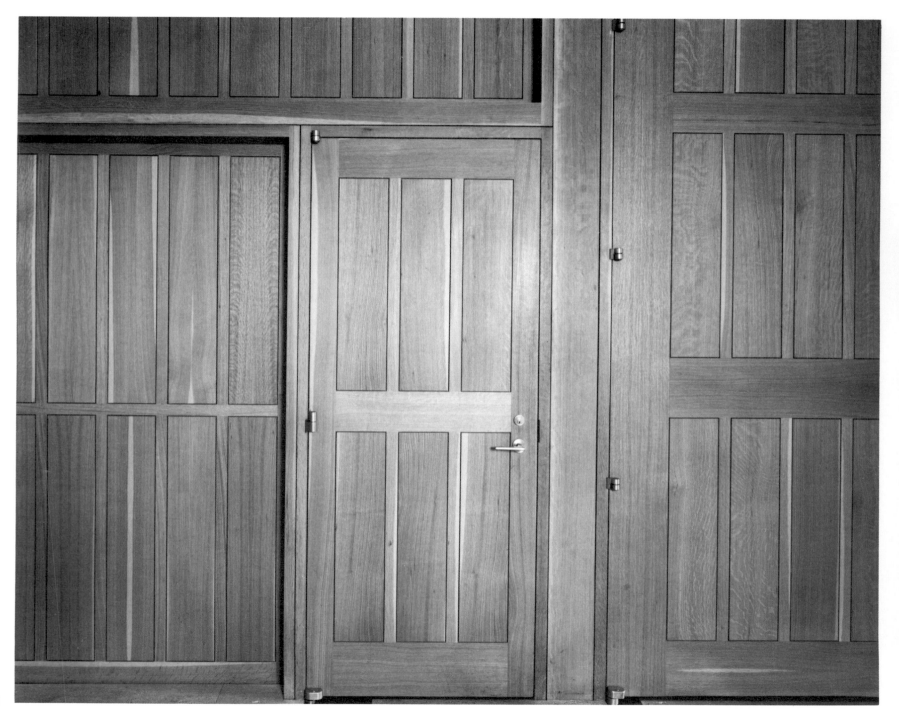

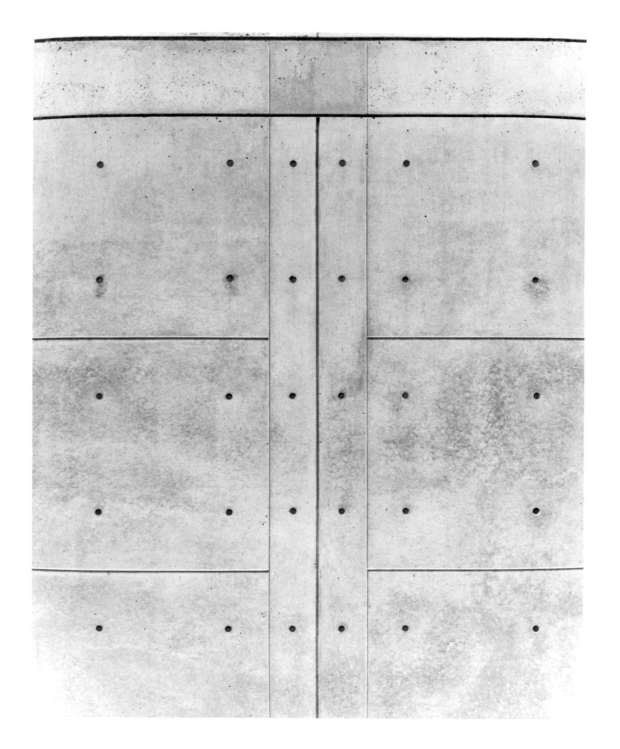

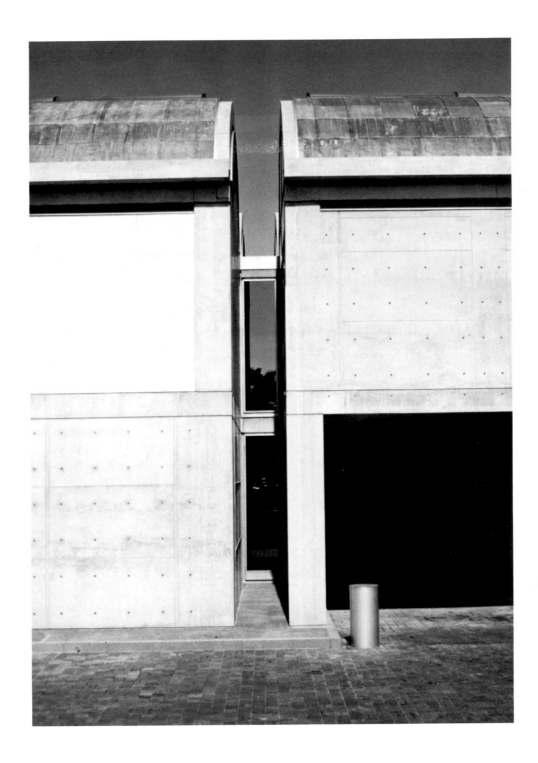

I put the glass between the structure members and the members which are not of structure because the joint is the beginning of ornament. And that must be distinguished from decoration which is simply applied. Ornament is the adoration of the joint.

Concrete does the work of structure, of holding things up. The columns are apart from each other. The space between must be filled. Therefore, the travertine. The travertine is a fill-in material. It is a wall material which is an enclosing material . . . . Travertine and concrete belong beautifully together because concrete must be taken for whatever irregularities or accidents in the pouring reveal themselves. Travertine is very much like concrete—its character is such that they look like the same material. That makes the whole building again monolithic and it doesn't separate things.

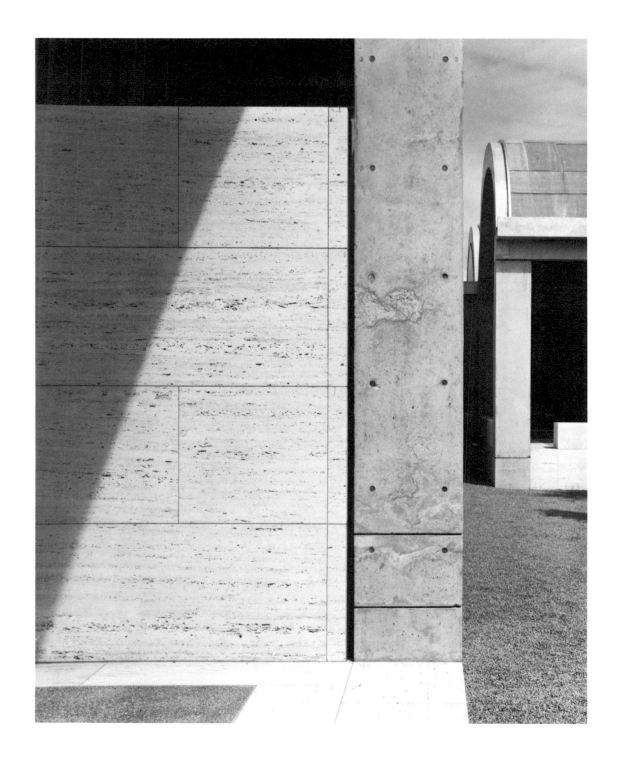

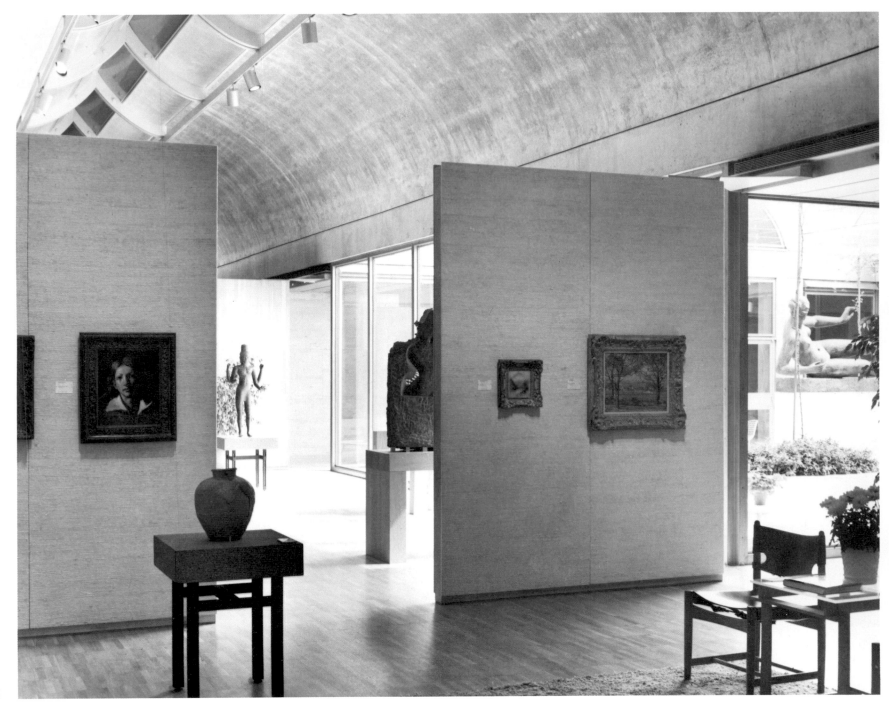

I don't like to see space nailed down. If you could move it and change it every day, fine.

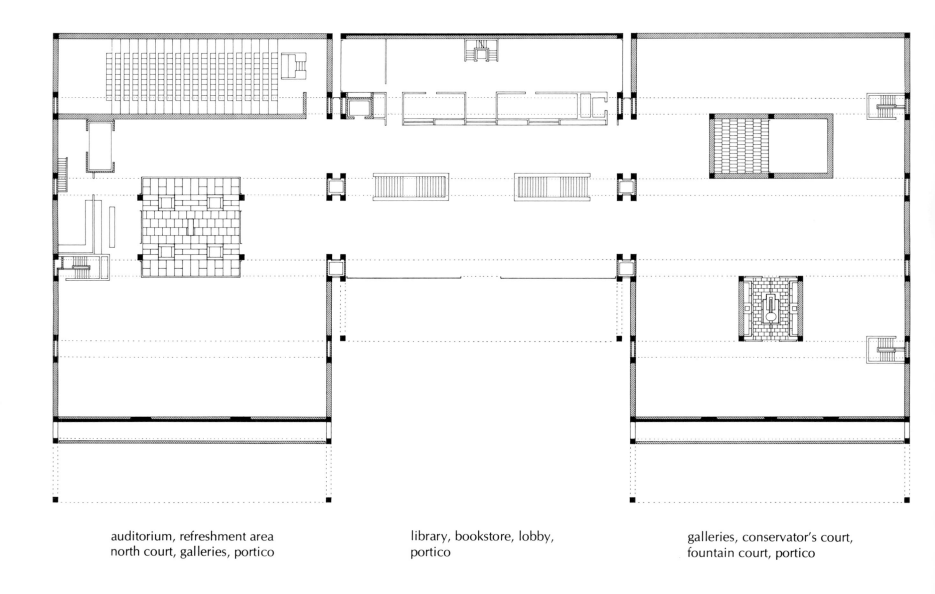

auditorium, refreshment area
north court, galleries, portico

library, bookstore, lobby,
portico

galleries, conservator's court,
fountain court, portico

UPPER LEVEL

N ←

| 0 | 5 | 20 | 40 F |
|---|---|----|------|
|   | 2 | 5  | 10 M |

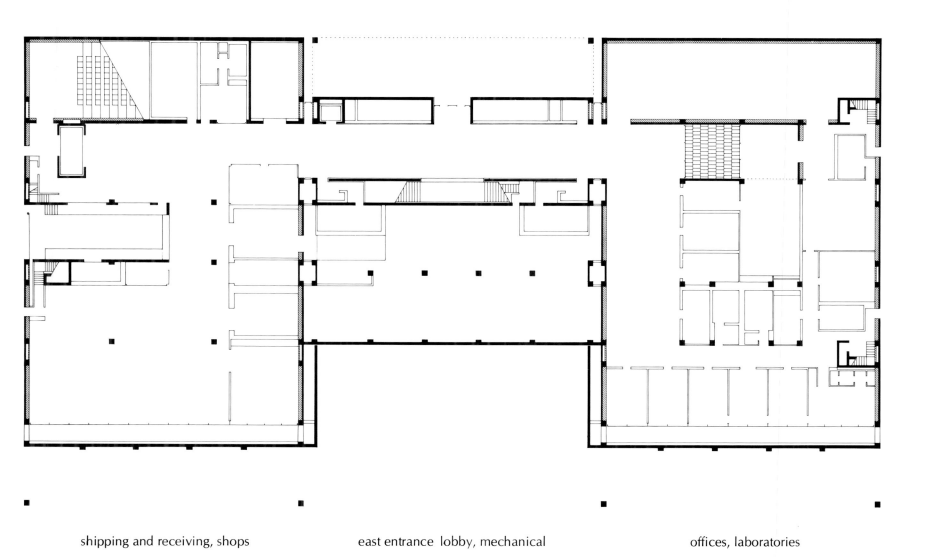

shipping and receiving, shops        east entrance  lobby, mechanical        offices, laboratories

LOWER  LEVEL

N ←        0   5        20        40 F

2        5        10 M

49

CLIENT: Well, now that we have the general form, we have to put in all the guts and see if we can fit them in.

KAHN: If they don't all fit in easily and properly, then we have the wrong form.

Engineering is not one thing and design another. They must be one and the same thing.

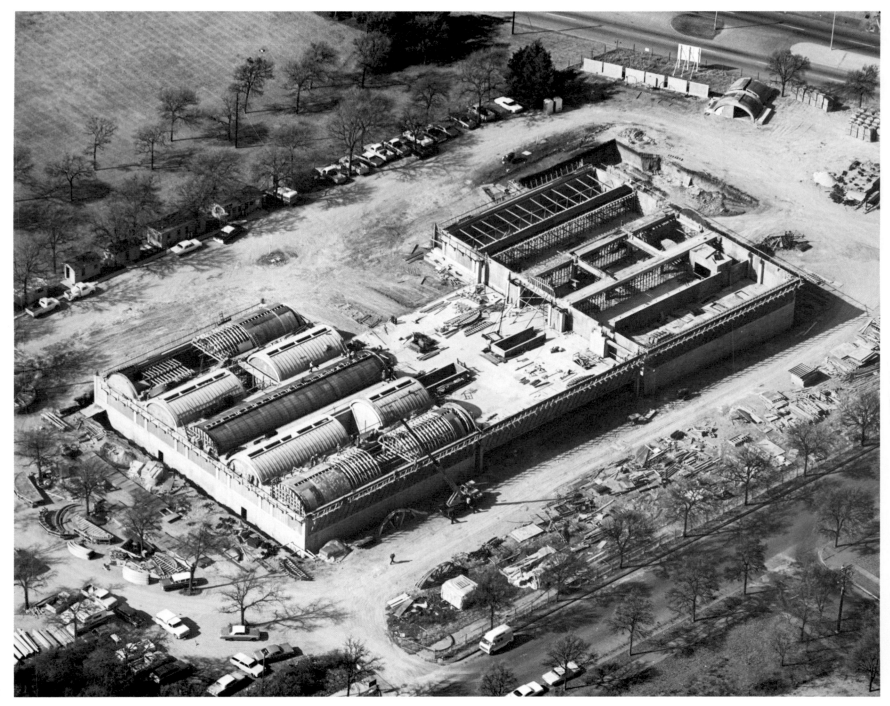

When you have all the answers about a building before you start building it, your answers are not true. The building gives you answers as it grows and becomes itself.

Listen to the man who works with his hands. He may be able to show you a better way to do it.

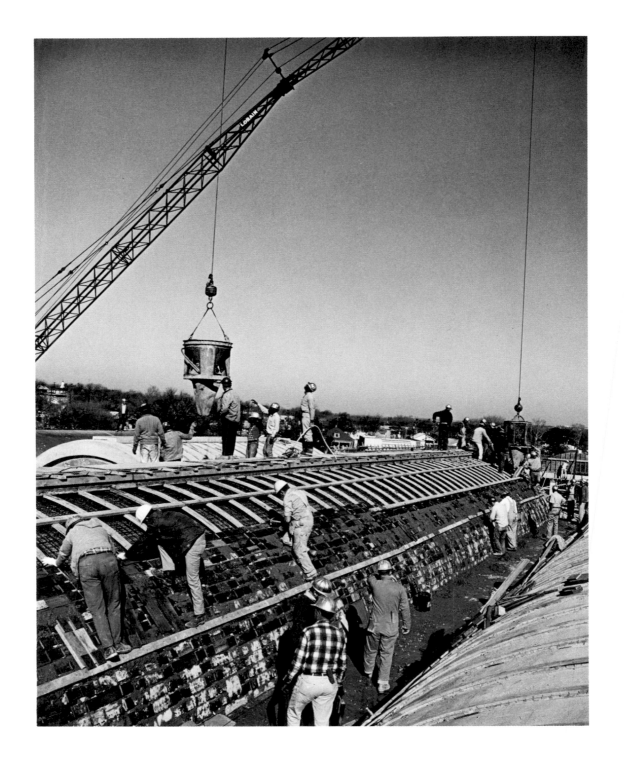

55

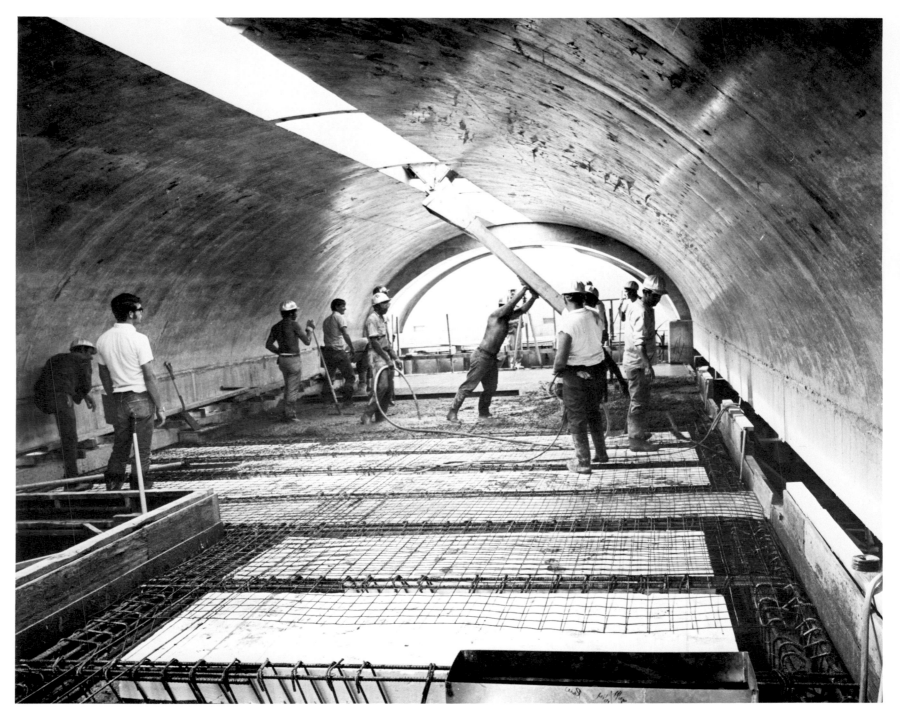

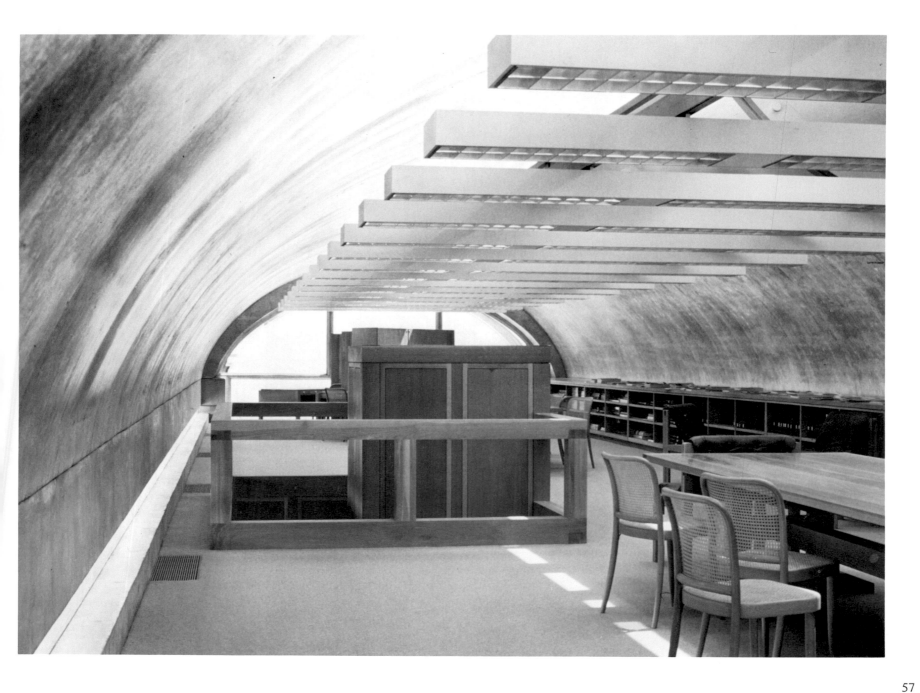

It is much better not to cover anything up but to show the full nature and relationship of part to part, including the present condition of each which is a record of how it got that way.

The world cannot be expected to come from the exercise of present technology alone to find the realms of new expression. I believe that technology should be inspired. A good plan demands it.

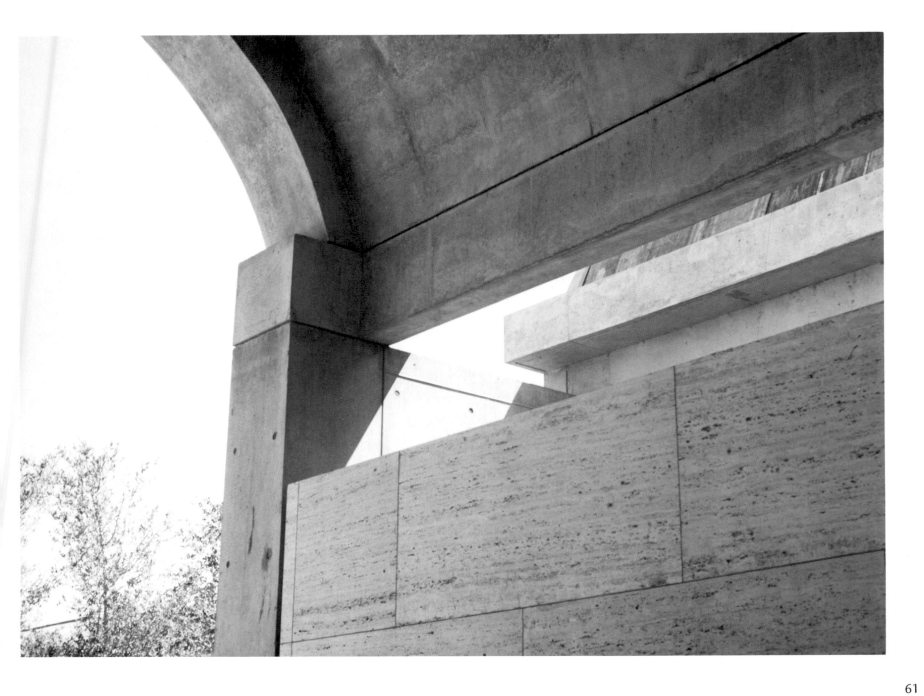

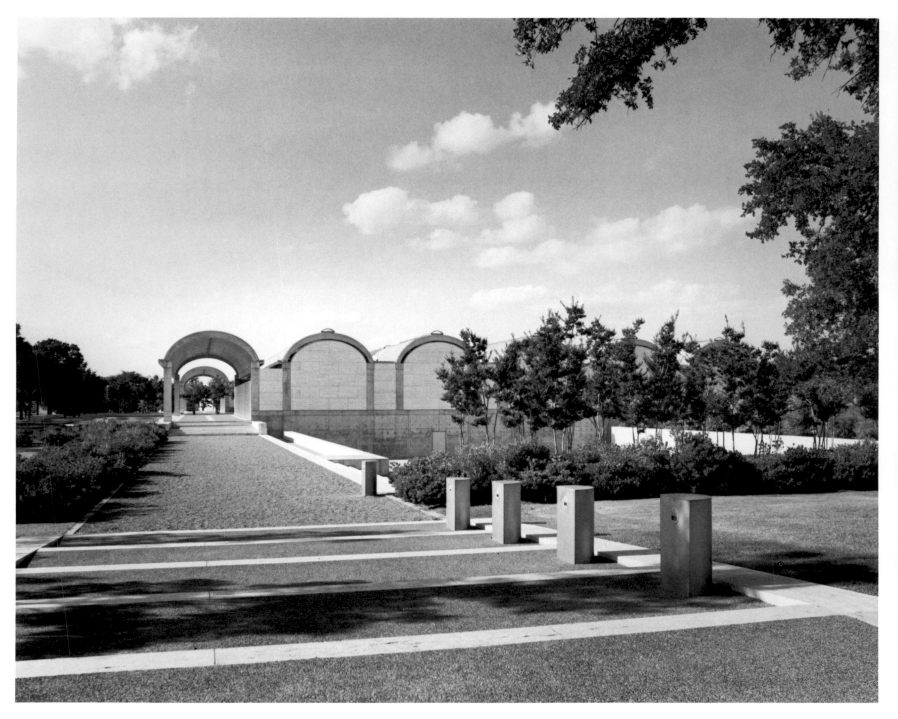

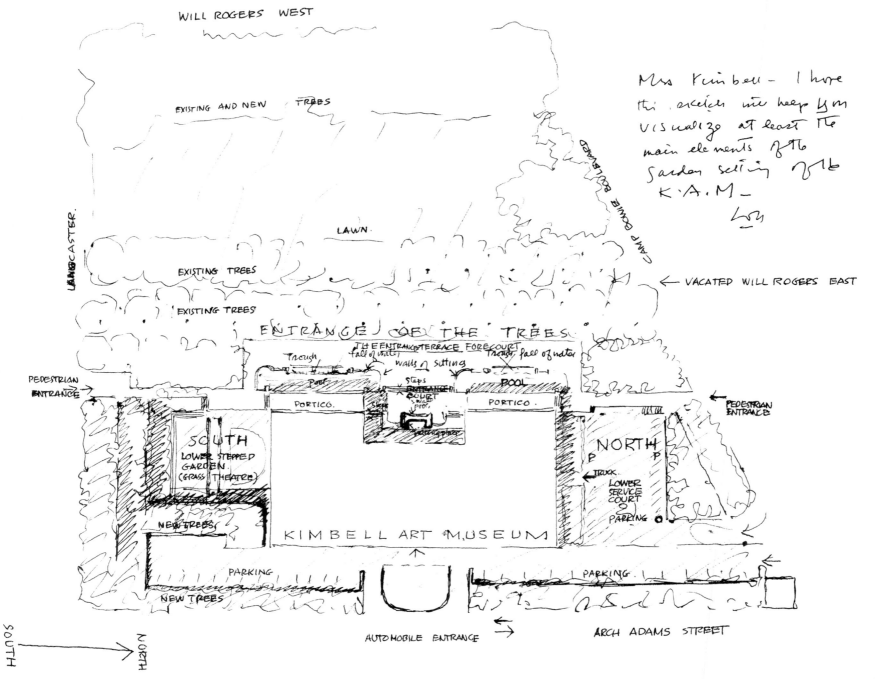

WILL ROGERS WEST

EXISTING AND NEW TREES

LAWN.

EXISTING TREES

EXISTING TREES

CAMP BOWIE BOULEVARD

LANCASTER.

Mrs Kimbell — I hope
this sketch will help you
visualize at least the
main elements of the
garden setting of the
K · A · M —

← VACATED WILL ROGERS EAST

ENTRANCE OF THE TREES

The ENTRANCE·TERRACE FORECOURT

Trough    fall of water    Trough fall of water

walls n sitting

Pool    Steps    POOL

PEDESTRIAN ENTRANCE →

PORTICO.    ENTRANCE COURT    PORTICO.

PEDESTRIAN ENTRANCE

SOUTH
LOWER STEPPED
GARDEN.
(GRASS THEATRE)

NORTH
P        P

TRUCK.
LOWER
SERVICE
COURT
& PARKING

NEW TREES

KIMBELL ART MUSEUM

PARKING    PARKING.

NEW TREES

SOUTH    NORTH

AUTOMOBILE ENTRANCE    ARCH ADAMS STREET

Dear Mrs Kimbell:                                                    Wednesday June 25 '69

I plan to come to see you soon to show and explain
the garden ideas I have surrounding the Kimbell Art
Museum. I hope you will find my work beautiful
and meaningful.

The entrance of the trees is the entrance by foot which
links Camp Bowie Boulevard and West Lancaster Ave.
Two open porticos flank the entrance court of terrace.
In front of each portico is a reflecting pool which drops its
water in a continuous sheet about 70 feet long in a basin two
feet below. The sound would be gentle. The stepped entrance
court passes between the porticos and their pools with a fountain,
around which one sits, on axis designed to be the source of the portico
pools.      The west lawn gives the building perspective.

The south garden is at a level 10 feet below the garden entrance
approached by gradual stepped lawns shaped to be a place to sit
to watch the performance of a play music or dance the building
with its arched silhouette acting as the back drop of a stage. When
not so in use it will seem only as a garden where sculpture acquired
from time to time would be.

The North Garden though mostly utilitarian is designed with
ample trees to shield and balance the south and North sides of the building

The car entrance and parking is also at the lower level. running parallel to Arch Adams street, This end too is lined with trees designed to overhang the cars as shelter. For This we must choose the right tree whose habits are respectful to the car tops,

When I see you I expect to bring a model which almost say more than my little words.

By now you know that I cannot be present at the ground breaking ceremony, Unfortunately I have emergency duties in India at the same Time. In my absence I wish everything well,

I am confident that the work will progress well from now on. I believe every one believes in the building and its good purposes.

I expect to return from India by the 12th of July. I will need a few weeks to firm up the material I hope to present to you for discussion.

Sincerely Yours

Lou I Kahn

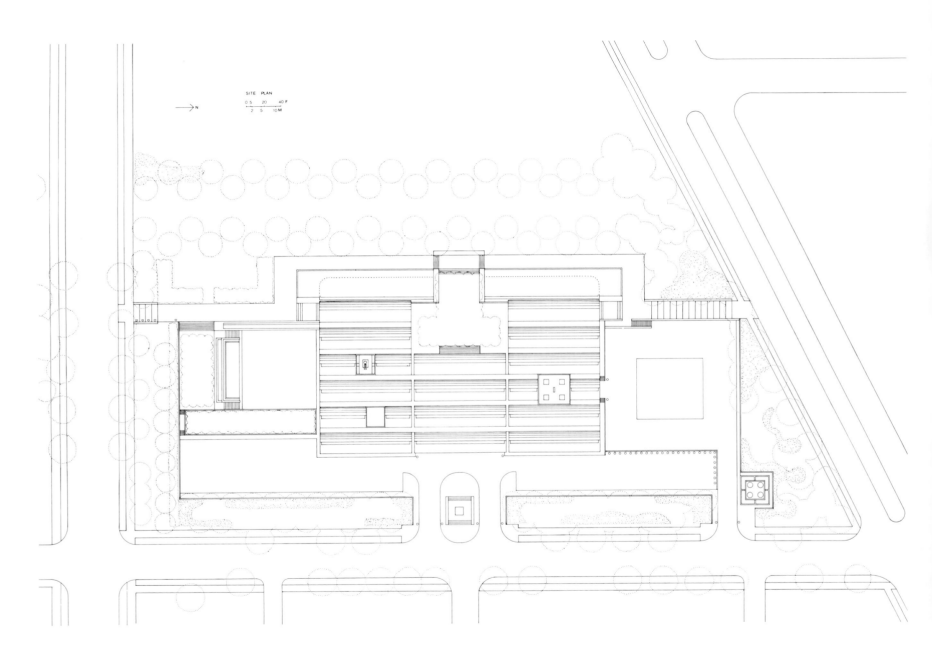

SITE PLAN

N →

0.5    20    40 F
2    5    10 M

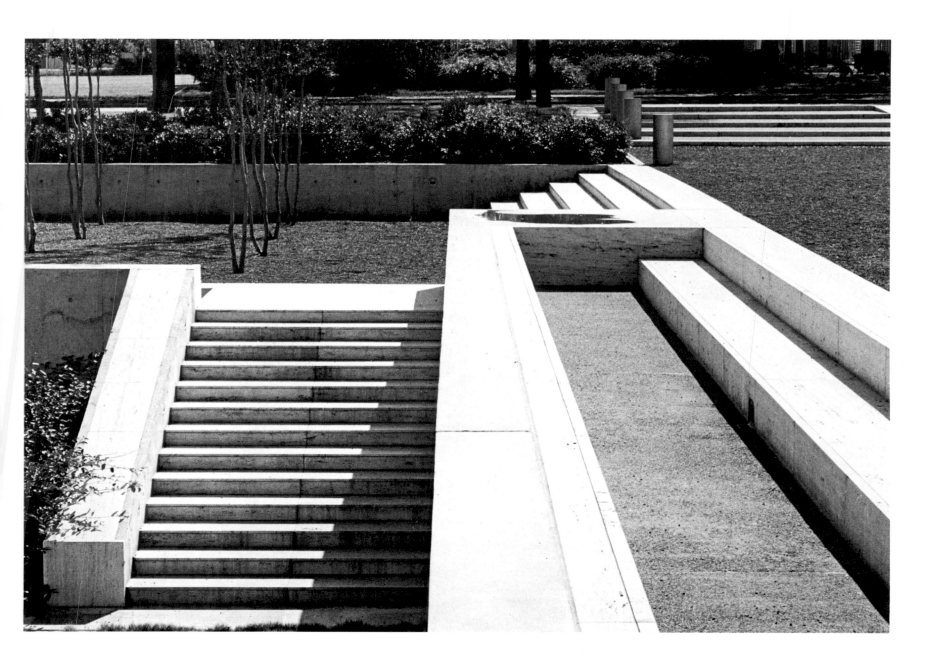

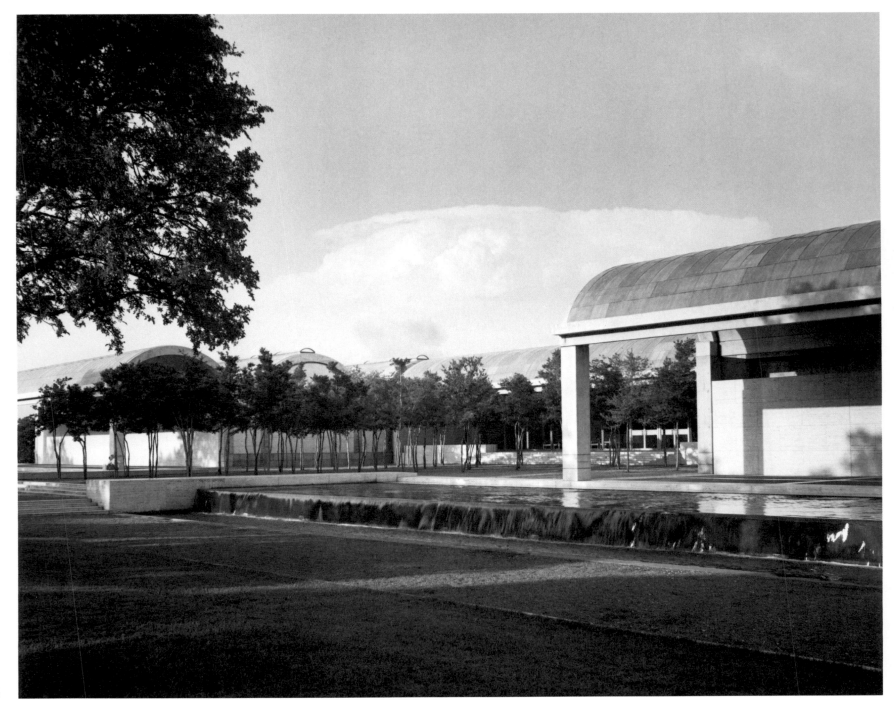

I don't believe in need as a force at all. Need is a current, everyday affair. But desire—that is something else again. Desire is the forerunner of a new need. It is the yet not stated, the yet not made which motivates.

A module is not the repetition of a motif but the expression of an architectural principle.

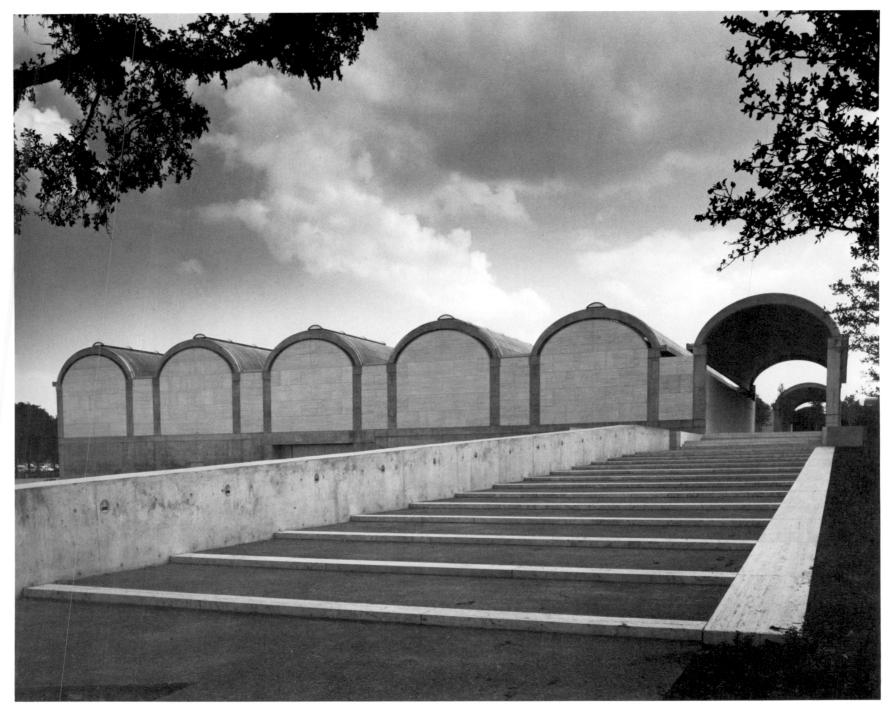

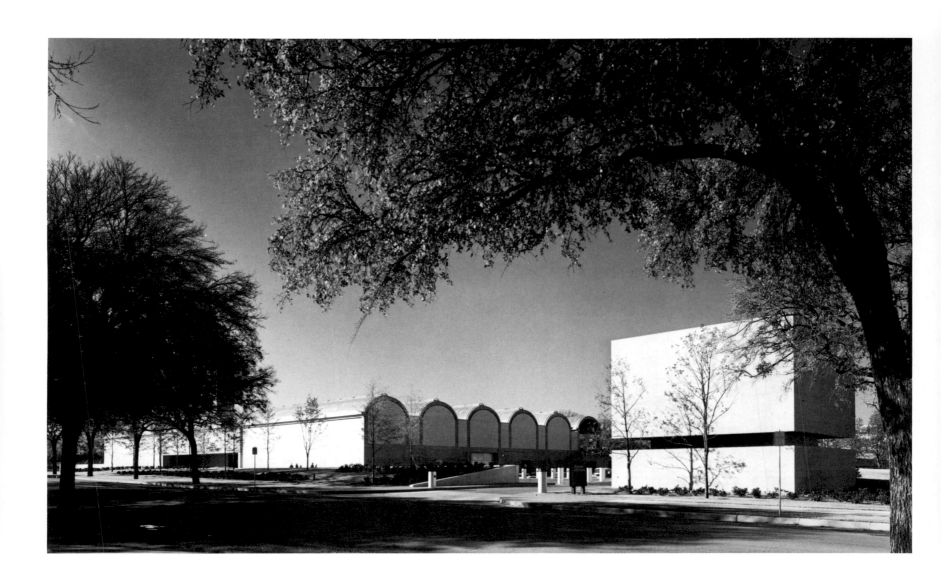

This building feels—and it's a good feeling—that I had nothing to do with it, that some other hand did it.

ARCHITECT

Louis I. Kahn, FAIA, architect
Project architect: Marshall D. Meyers

Associate architect: Preston M. Geren and Associates
Project coordinator: Frank H. Sherwood

CONSULTANTS

Structure: August E. Komendant
Lighting: Richard Kelly; Edison Price
Acoustics: C. P. Boner and Associates
Landscape: George Patton
Graphics and exhibition design: Laurence Channing
Electronics: Thomas Electronics

CONSTRUCTION

Thos. S. Byrne, Inc., general contractor
Project manager: A. T. Seymour, III
Job supervisor: Virgil Earp
Landscape: Vernon S. Swanson

CLIENT

Kimbell Art Foundation
Museum director: Richard F. Brown
On-site representative: E. B. Brown

CHRONOLOGY

| | |
|---|---|
| Oct. 6, 1966 | Architectural contract let |
| May 5, 1969 | General construction contract let |
| June 29, 1969 | Groundbreaking |
| Oct. 4, 1972 | Opening |

AWARDS

1972    Best Building Award, National General Contractors Assn.

1973    Lumen Award, Illuminating Engineers Society

1975    Honor Award and Bartlett Award, American Institute of Architects

1975    Engineering Excellence Award, Consulting Engineers Council of Texas, Inc.

## SITE

The museum is situated on nine and one-half acres in Amon Carter Square Park, a cultural complex including the Amon Carter Museum of Western Art, The Fort Worth Art Museum, the William Edrington Scott Theater, the Fort Worth Museum of Science and History, the Will Rogers Memorial Coliseum and Auditorium and the Casa Manana Theater.

## ORGANIZATION

Sixteen narrow rectangular vaulted elements are laid out in three sections with six vaults side by side on each end and four in the middle; flat-roofed inverted channels separate the vaults. Two elements are eliminated in the center of the west side to make an entrance court. The sloping site gives public access from this court to the upper (gallery) level. Lower-level access is from parking lots on the north and east sides. The vaulted roofs articulate specific areas on the gallery level while interior courtyards punctuate the flow of open space. The east entrance lobby separates the sections on each end which house administrative and shop areas. Mechanical and electrical distribution systems are contained in a full basement.

## STRUCTURE

Vaults are roofed by 23' × 100' clear-span cycloid shells of post-tensioned reinforced concrete. Each is supported on four 2' x 2' corner columns. Vaults covering interior spaces have a longitudinal 2½' slit at the apex with concrete cross struts every 10'. Lower edges of the shells support 7' reinforced concrete channels with aluminum soffits which house the air and electrical distribution systems. Exterior travertine infill walls have a reinforced concrete core between columns. Two-way post-tensioning is used in upper-level floor slabs. The lower level is conventional poured-in-place concrete of pan-formed slab and joist construction.

## MATERIALS

Exterior: Poured-in-place concrete with as-cast surface is used for the structure. Diamond-sawn, unfilled travertine veneer from Bagni di Tivoli, Italy, is used for infill walls, court paving, steps and wall copings. Calcium lead sheets roof the shells. The public parking area is of dark brown square brick pavers. Cedar brown marble aggregate is used for the staff parking lot, walkways, and pool bottoms. Loose chips of the marble cover the entrance court beneath the rows of yaupon holly trees. Curbs and pool linings are of Andes black granite. Double insulating glass is used on the gallery level; Plexiglas covers the light slits. Doors and frames, windows and bollards are of mill-finish stainless steel.

Interior: The same as-cast concrete is used for the structure and travertine for infill walls, stairs, balustrade and portions of floors. Remaining gallery flooring, doors, frames and cabinetwork are of quarter-sawn white oak. Slate flooring is used in the kitchen. Soffits and reflectors are made of anodized aluminum. Mill-finish stainless steel is used for elevators and kitchen, with blasted mill-finish stainless steel for handrails.

## DIMENSIONS

Gross area is 120,000 sq. ft. (11,150m²) and the public gallery area approximately 30,000 sq. ft. Overall length (north-south) is 318'. Width at the widest roofed area is 174' and at the narrow center section, 114'. Height to the apex of a vault from the floor is 20', and overall height from the lowest (east) ground level is 40'.

## COST

Construction: $6,500,000.00

Equipment and Furniture: $1,000,000.00

## CREDITS

Photography: Robert Wharton: 13, 19, 20, 24, 30, 39, 51, 52, 55, 56, 58, 62, 67, 68, 71; Marshall D. Meyers: 14, 25, 26, 41, 42, 46, 57, 61; Geoff Winningham: 29, 35, 40, 45; Robert Shaw: cover, 23, 36; Ezra Stoller: 10, 72; B. V. Doshi, 9.

Plans: Anna Ku

SELECTED BIBLIOGRAPHY

These references are in addition to sources cited in the index. For discussions of the architectural program, the evolution of design and for illustrations of early sketches and models, see: Peter Plagens, "Louis Kahn's New Museum in Fort Worth," *Artforum,* vol. VI, no. 6, February, 1968, pp. 18-23; "Kahn's Museum: An Interview with Richard F. Brown," *Art in America,* September-October, 1972, pp. 44-48; Heinz Ronner, ed., *Louis I. Kahn: Complete Work, 1935-74,* Zurich, 1977, pp. 343-51; and *Louis I. Kahn: Sketches for the Kimbell Art Museum,* catalogue of exhibition organized by D. M. Robb, Jr., with essay by Marshall D. Meyers, published by Kimbell Art Museum, 1978. Structural design, engineering and construction are discussed in: "Post-tensioned Shells Form Museum Roof," *Engineering News-Record,* vol. 187, no. 20, Nov. 11, 1971, pp. 24-25; A. T. Seymour, III, "Contractor Challenged by Kimbell Art Museum Design," *Texas Contractor,* November, 1972; August E. Komendant, *Contemporary Concrete Structures,* New York, 1972, pp. 504-8; and Komendant, *18 Years with Architect Louis I. Kahn,* Englewood, N.J., 1975, pp. 115-31. Architectural assessments and/or comprehensive illustrations are presented in: "Louis I. Kahn: Silence and Light," *Architecture and Urbanism,* vol. 3, no. 1, Tokyo, January, 1973, pp. 36, 65, 106-12; William Jordy, "The Span of Kahn," *The Architectural Review,* vol. CLV, no. 928, June, 1974, pp. 318-42; "Louis I. Kahn: Memorial Issue," *Architecture and Urbanism,* Tokyo, 1975, pp. 53-72, 208-9, 225-26, with essay, "Contemporary Classic: Kimbell Art Museum" by Famihiko Maki, pp. 315-21; "Honor Awards . . . ," *AIA Journal,* vol. 63, May, 1975, p. 39; Yukio Futagawa, "Louis I. Kahn: Yale Art Gallery and Kimbell Art Museum," *Global Architecture,* no. 38, Tokyo, 1976, pp. 18-40, 46-47, with essay by Marshall D. Meyers, pp. 2-7.

Designed by William D. Wittliff, Encino Press, Austin, Texas
Published in 1975 by Kimbell Art Foundation
Will Rogers Road West, Fort Worth, Texas 76107